CHRISTIAN VOGT

CHRISTIAN VOGT

Eighty-two Images
by Fifty-two Women

IN CAMERA

EDITION STEMMLE

Over a period of three years, I have asked more than fifty women if they would be willing to create an erotic image of themselves and bring it to life in my studio. They could bring along whatever accessories they wanted, and I added that, to me, being erotic didn't necessarily mean being nude – no one had to take off her clothes. My only consistent requirement was a wooden box – this was to appear in the picture in some way.

I did not select the women; they are merely women I met during this period and who wanted to participate. Their occupations are as diverse as their photographs – student, housewife, stewardess, saleswoman, costume designer, secretary, graphic designer, boutique owner, playmate, ballet dancer, stylist, medical assistant, architectural draftsman, waitress, gallery owner, nurse, teacher … And their ages vary as well; almost half are between twenty and thirty, a third are between thirty and forty, five are over forty and five are under twenty.

I photographed the entire series using a painted, curved backdrop. For background music I chose Jimmy Smith and Joe Henderson. During the sessions I saw myself, above all, as a medium, assuming an active role when I sensed that a situation arose that corresponded to the woman and her personality and her idea. The choice of which photo or photos to include in the book was made in collaboration with each of the women.

CHRISTIAN VOGT

PLATES

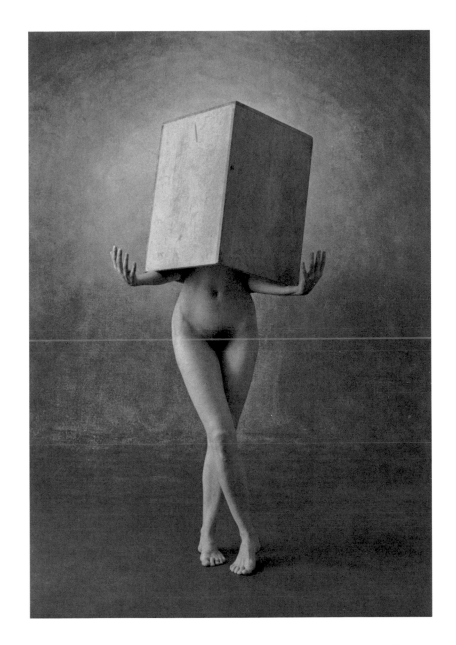

Barbara

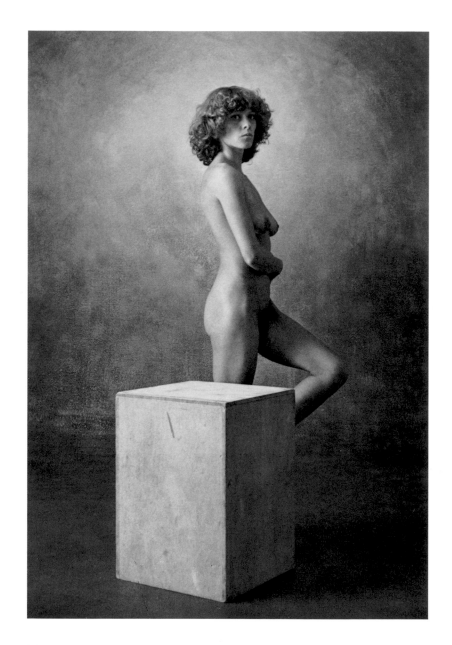

Rita

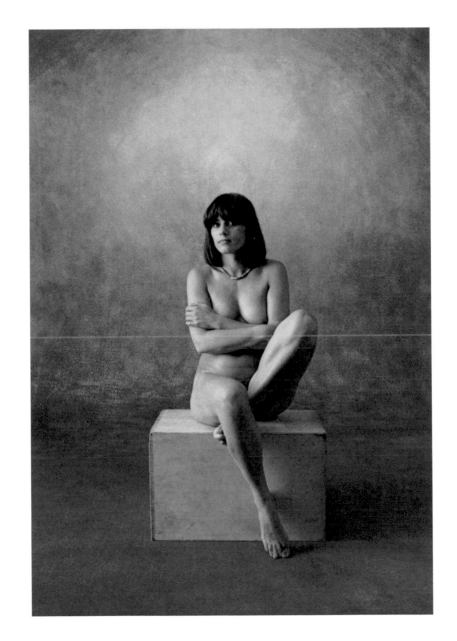

Irène

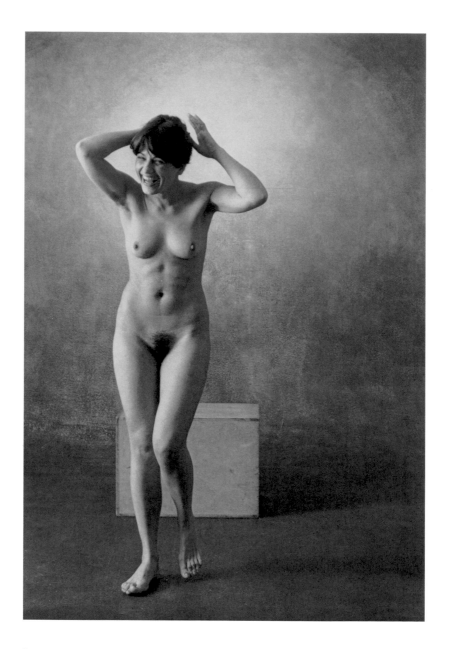

Irène

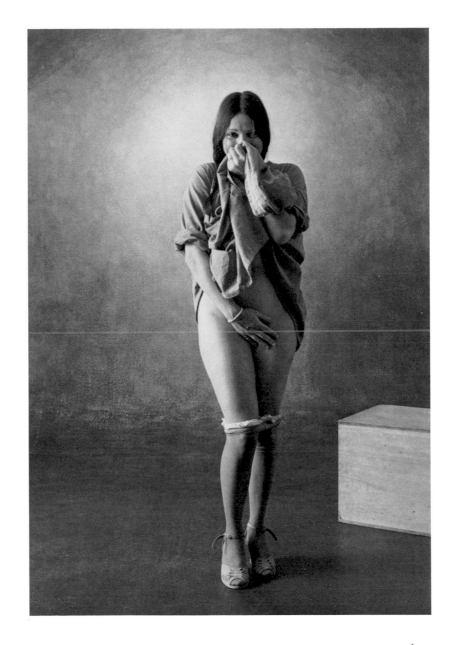

Inge

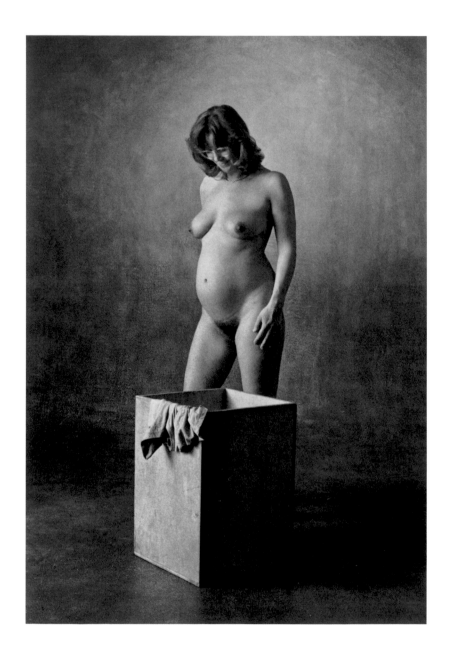

Béatrice

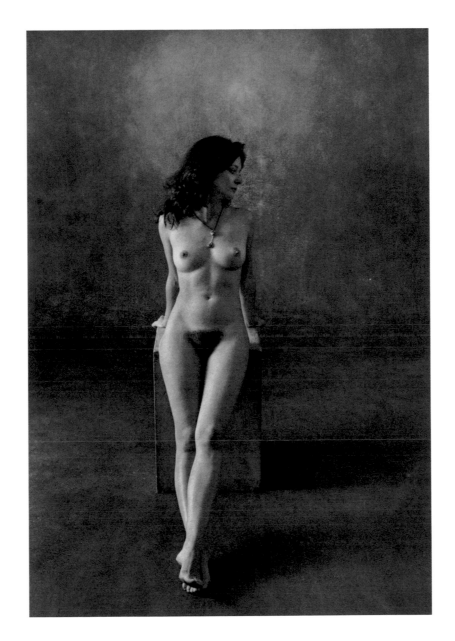

Michele

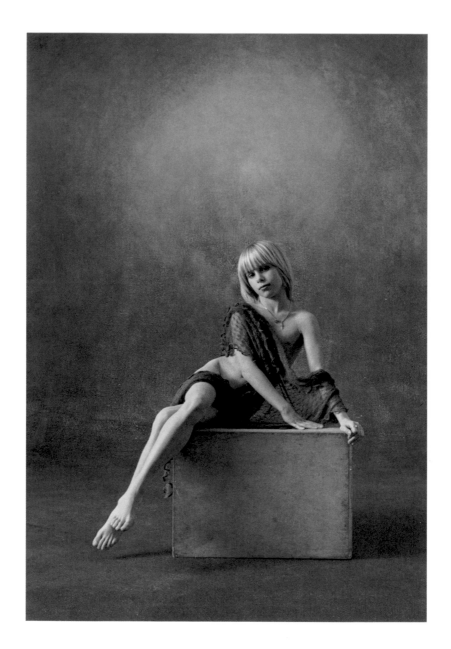

Nina, 1979

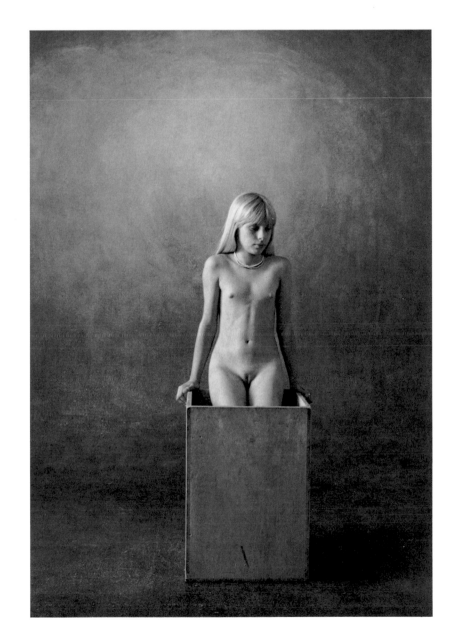

Nina, 1981

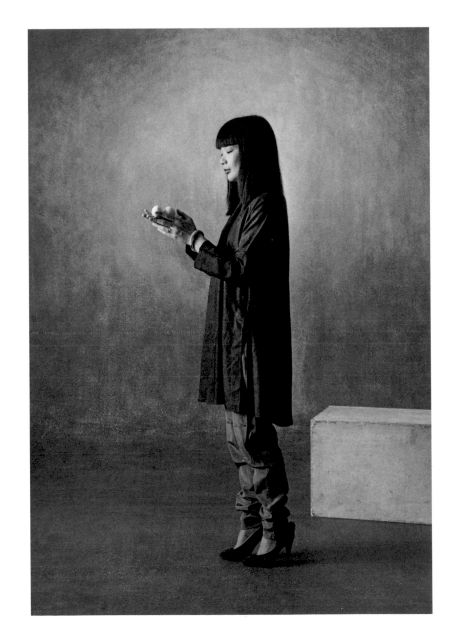

Toni

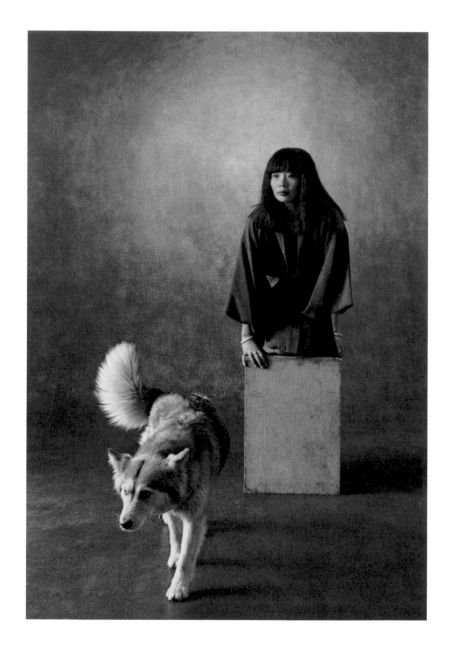

Toni

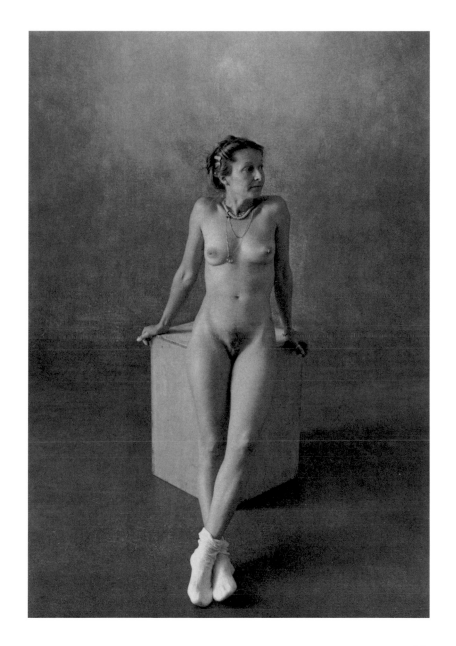

Iris

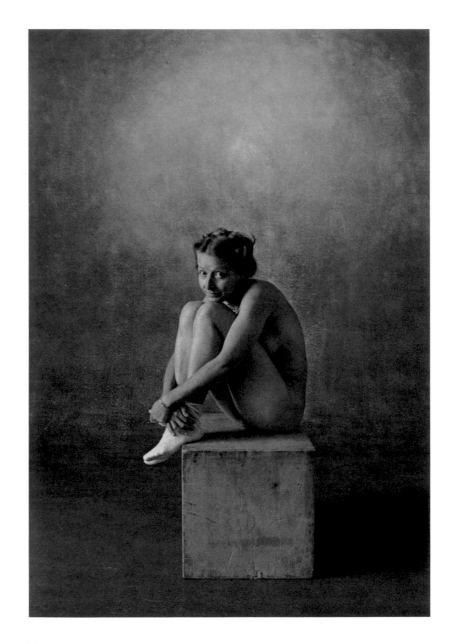

Iris

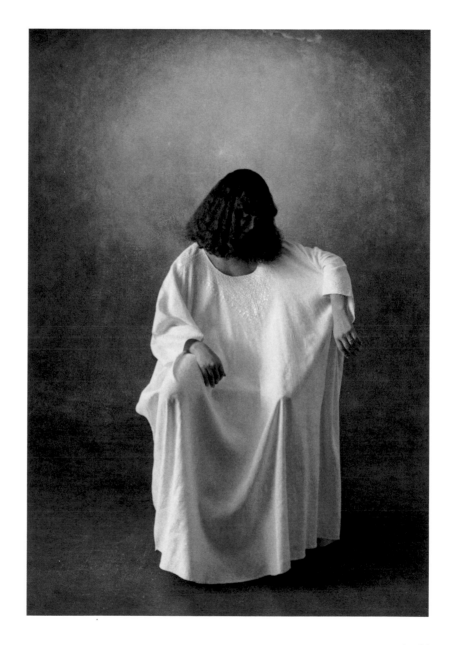

Astrid

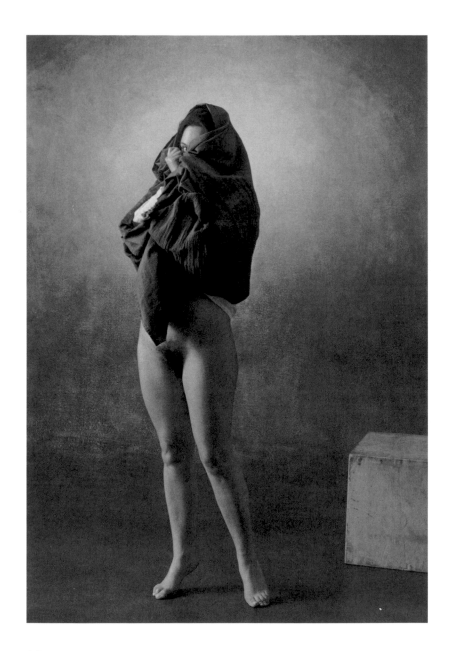

Sylvienne

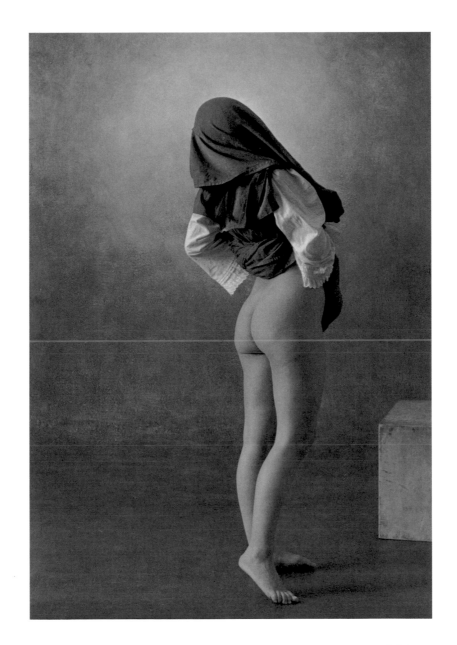

Sylvienne

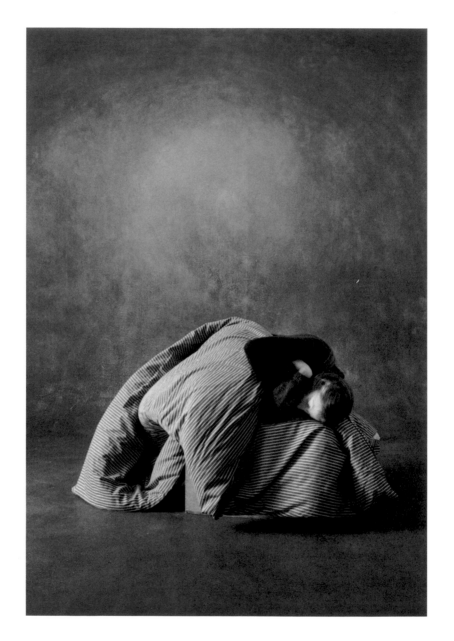

Giselle

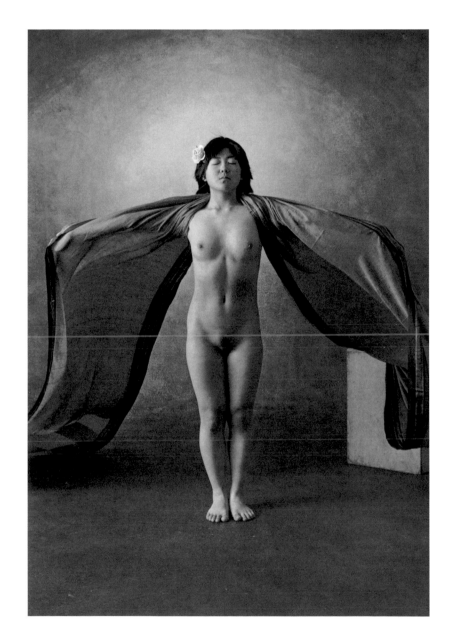

Anouk

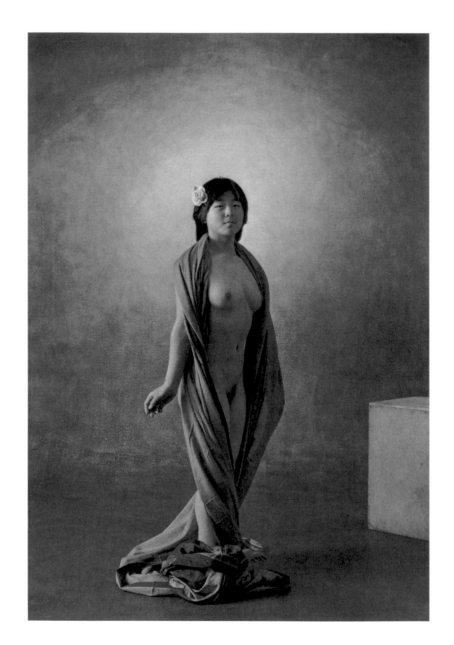

Anouk

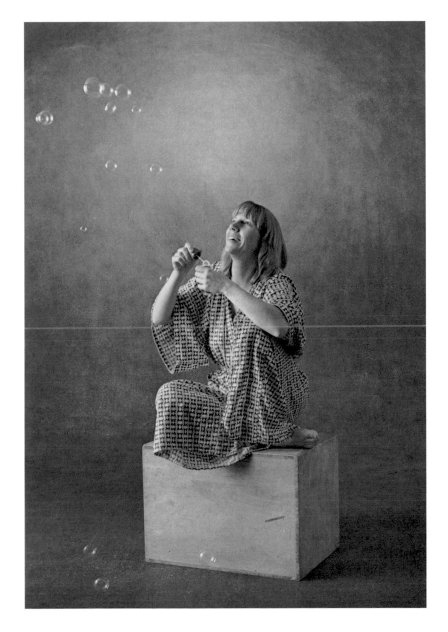

Susan

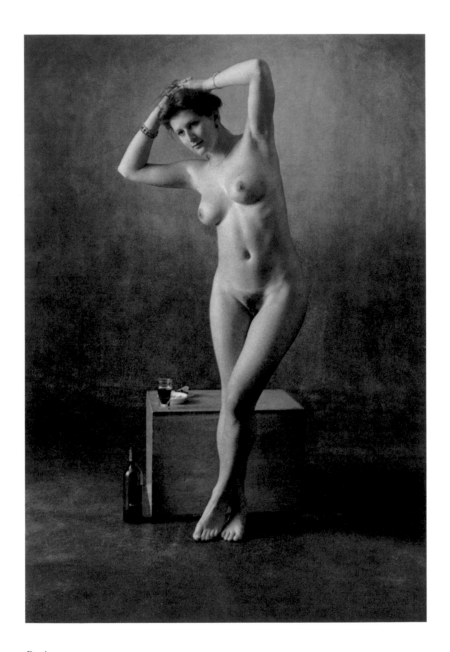

Regina

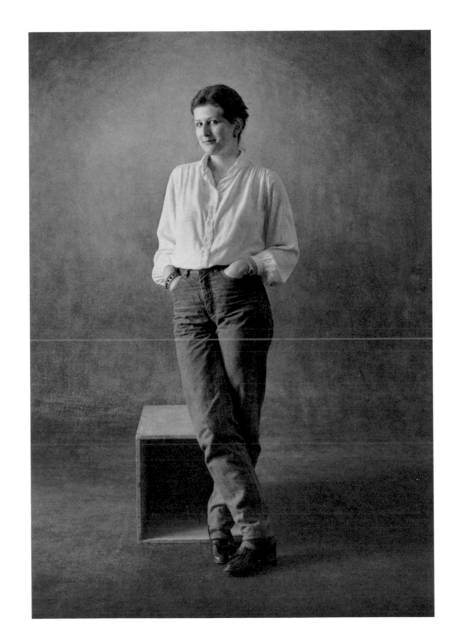

Regina

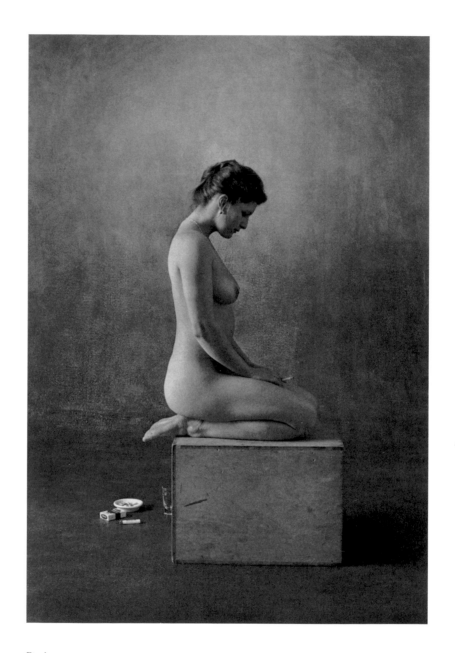

Regina

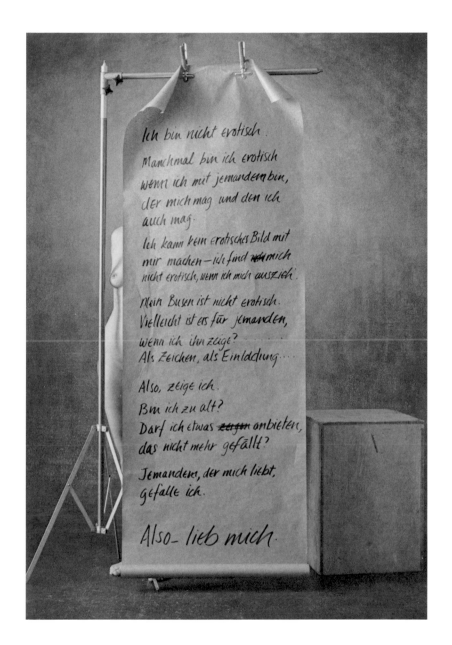

Ich bin nicht erotisch.

Manchmal bin ich erotisch
wenn ich mit jemandern bin,
der mich mag und den ich
auch mag.

Ich kann kein erotisches Bild mit
mir machen – ich find ~~mich~~ mich
nicht erotisch, wenn ich mich ausziehe.

Mein Busen ist nicht erotisch.
Vielleicht ist es für jemanden,
wenn ich ihn zeige?
Als Zeichen, als Einladung....

Also, zeige ich.

Bin ich zu alt?
Darf ich etwas ~~zeigen~~ anbieten,
das nicht mehr gefällt?

Jemanden, der mich liebt,
gefalle ich.

Also – lieb mich.

Nora

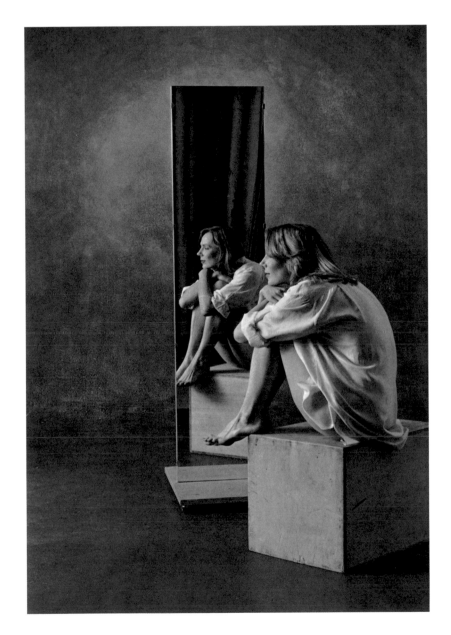

Anne-Catherine

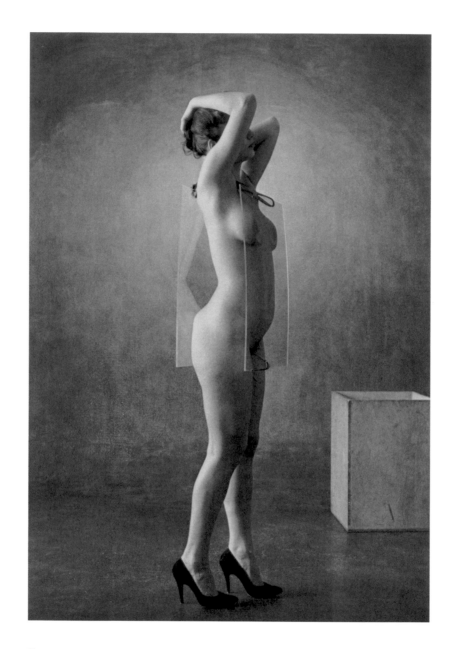

B.

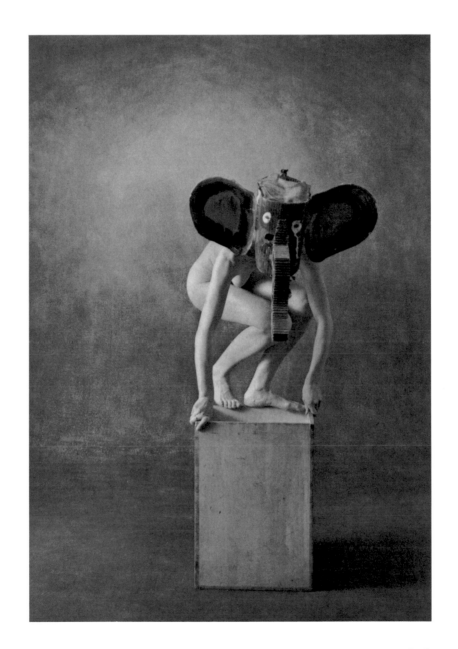

Ruth

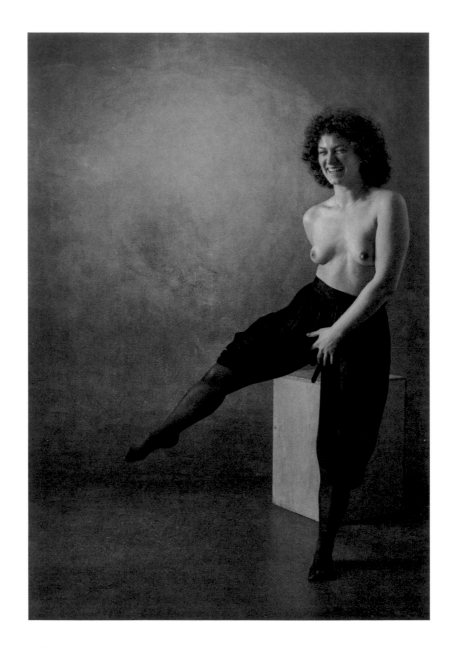

Jackie

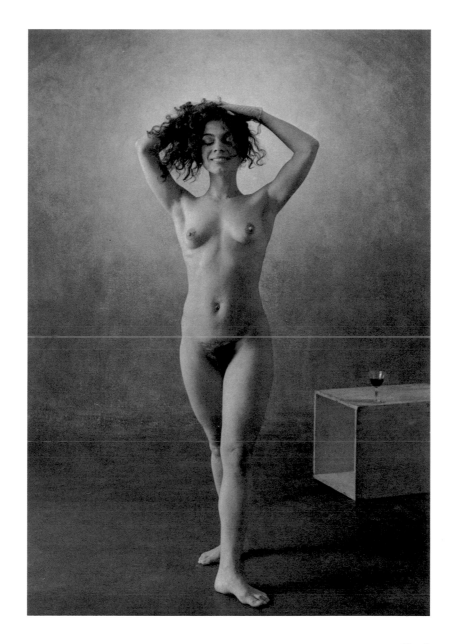

Trudi

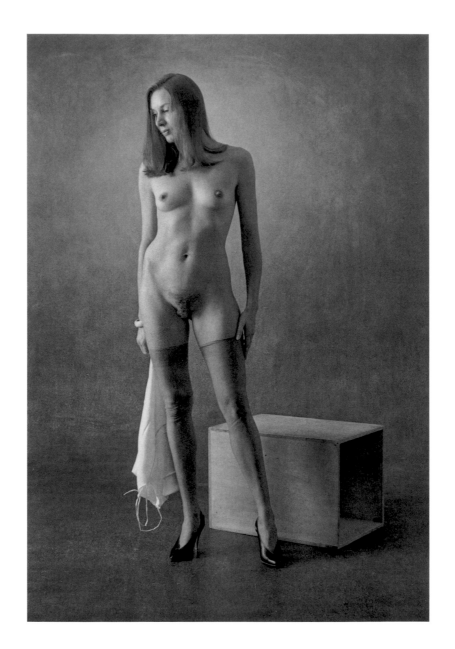

Shelley

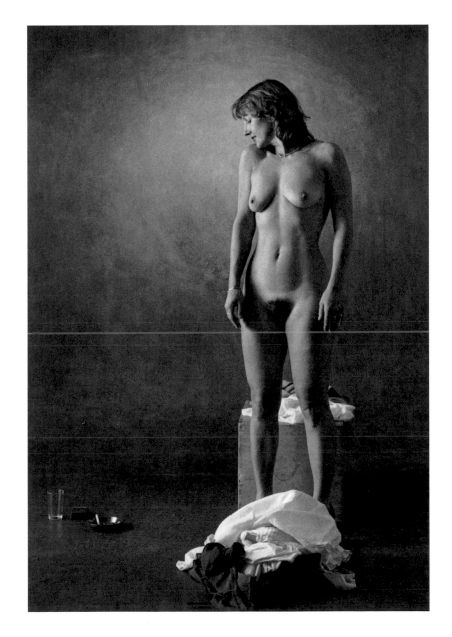

Nicole

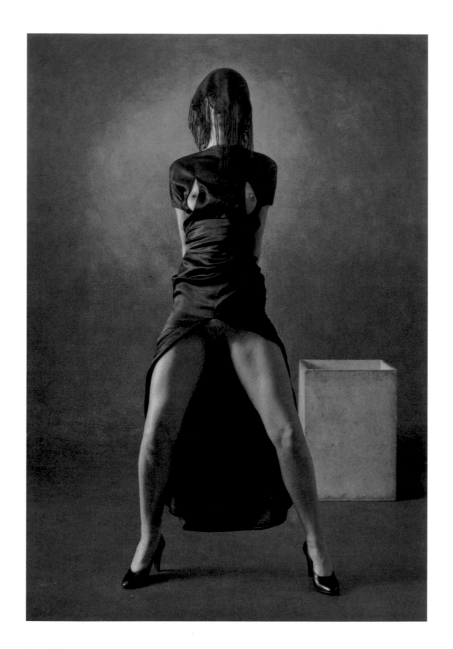

Angelika

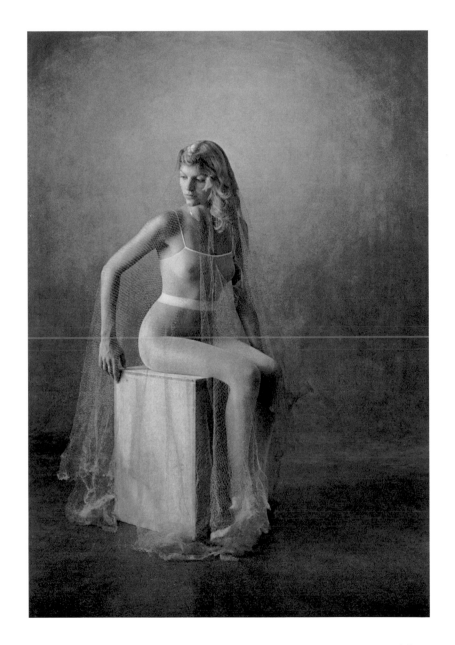

Arlette

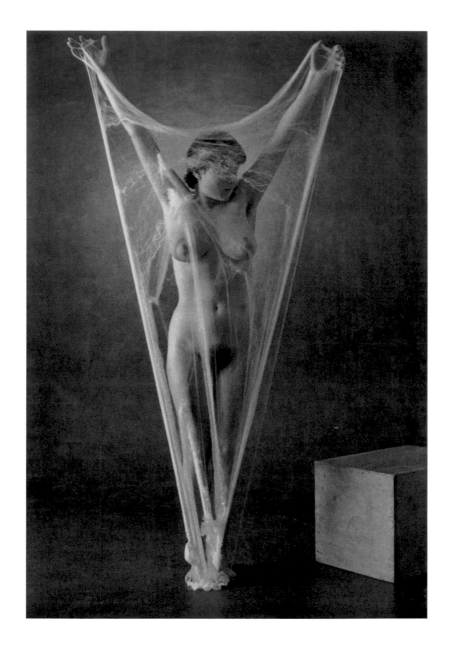

Christine

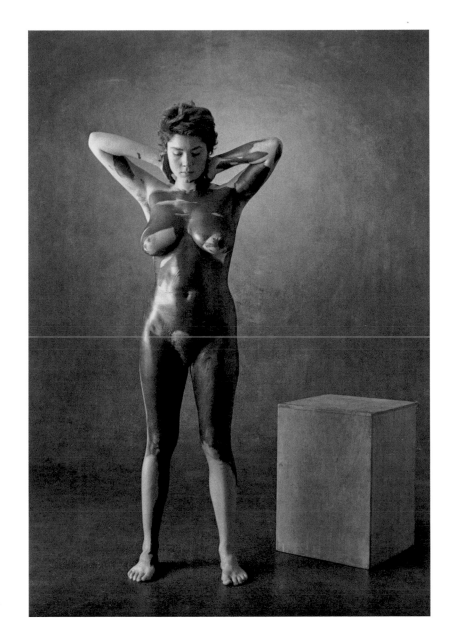

Christine

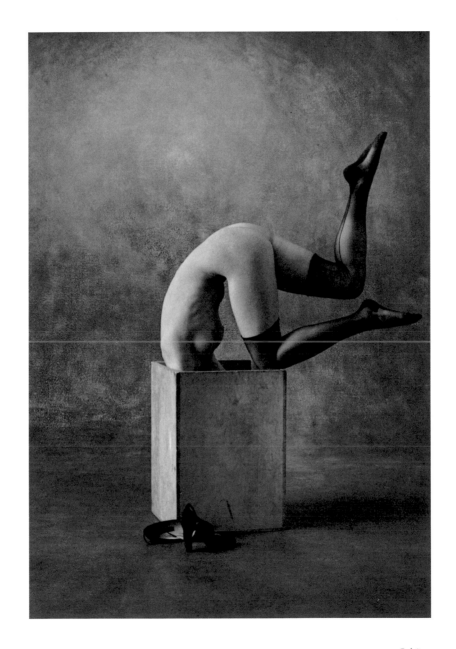

Sabine

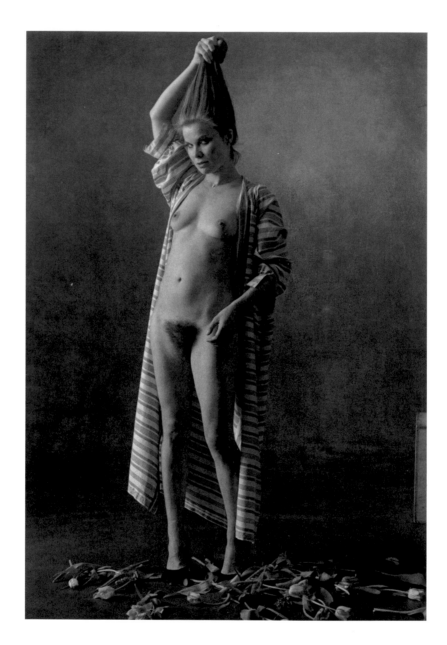

Marcellina

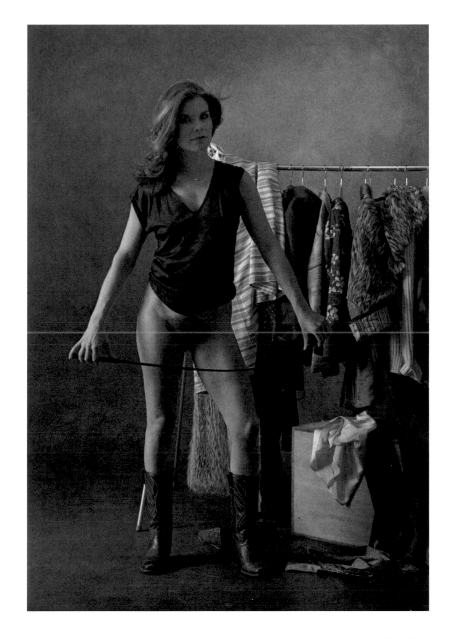

Marcellina

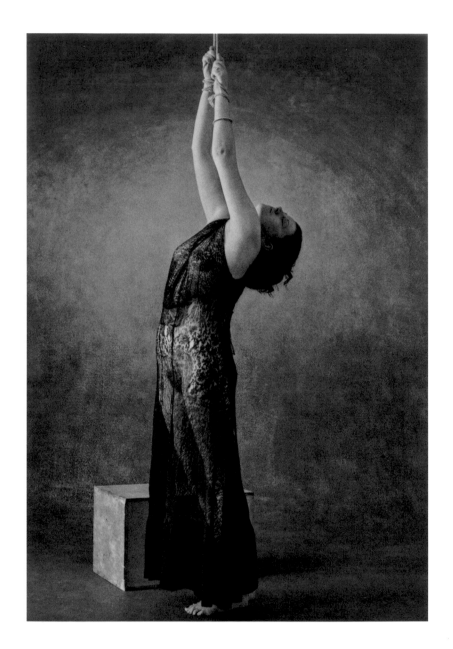

Dawn

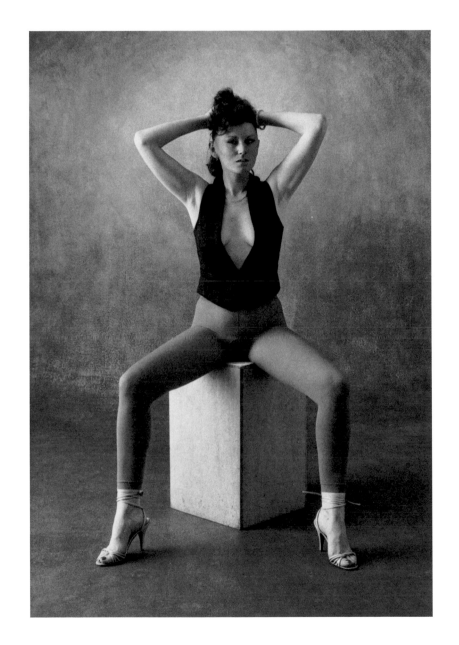

Dawn

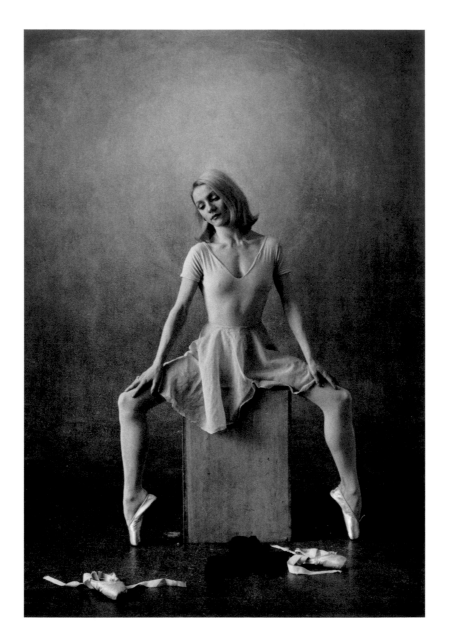

Emilietta

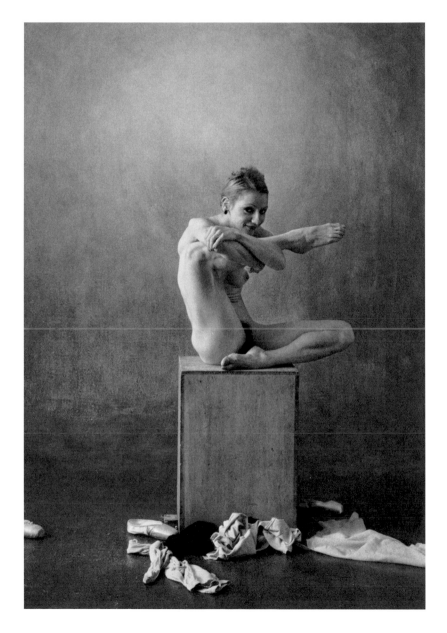

Emilietta

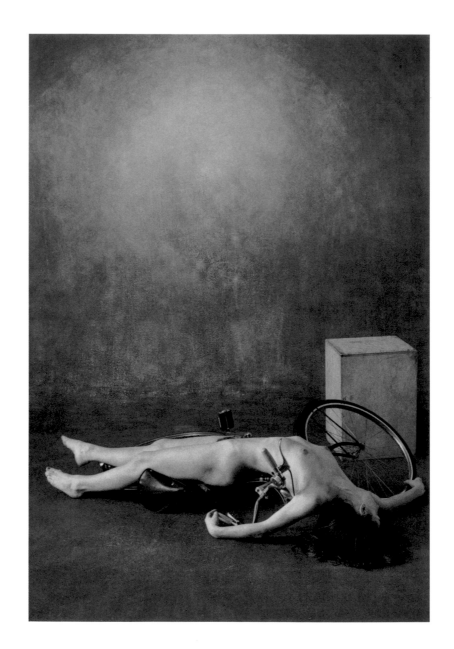

Renée

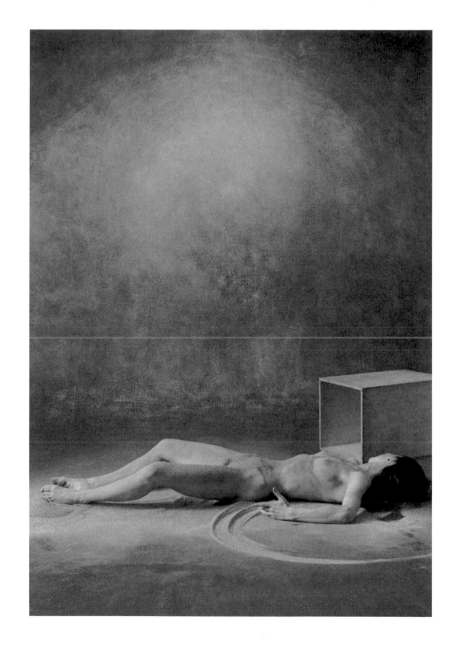

Renée

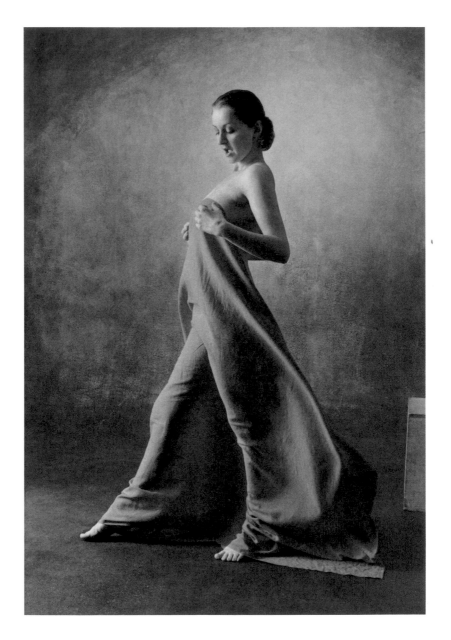

Stasia

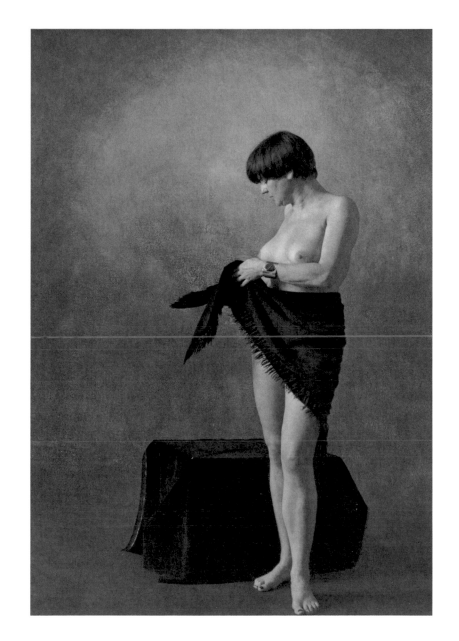

Hildi

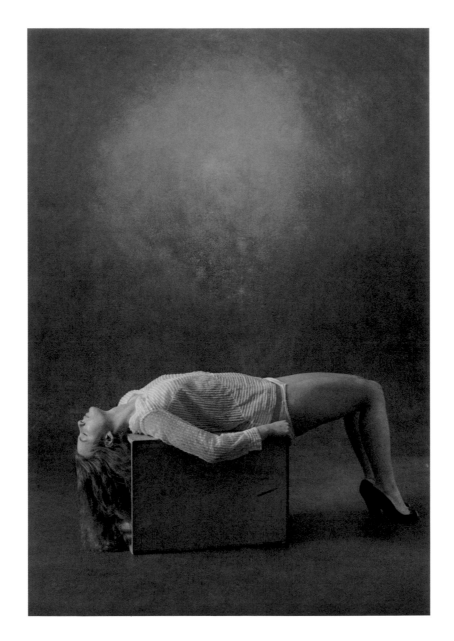

Romana

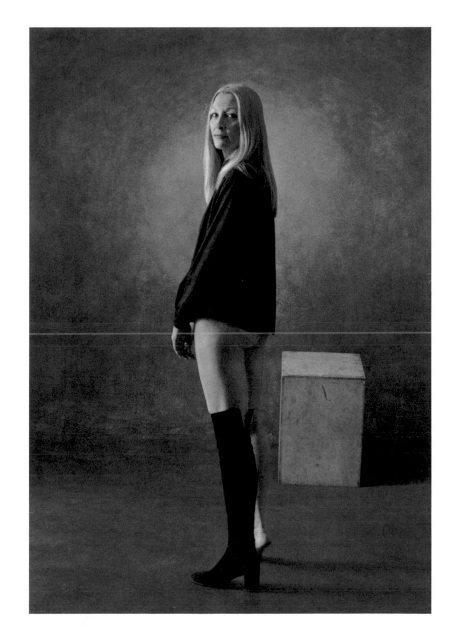

Maren

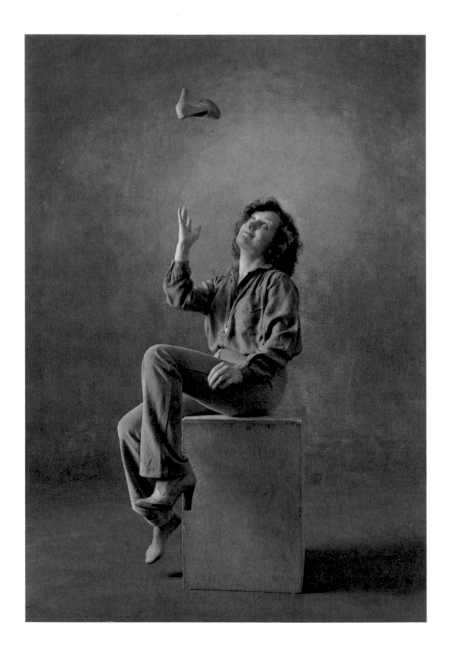

Esther

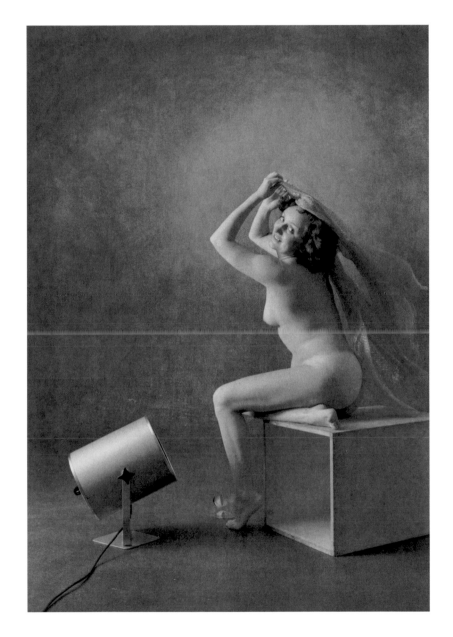

Esther

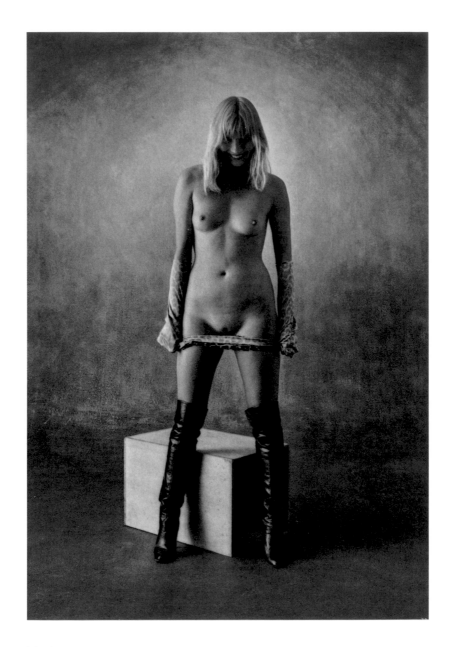

Monique

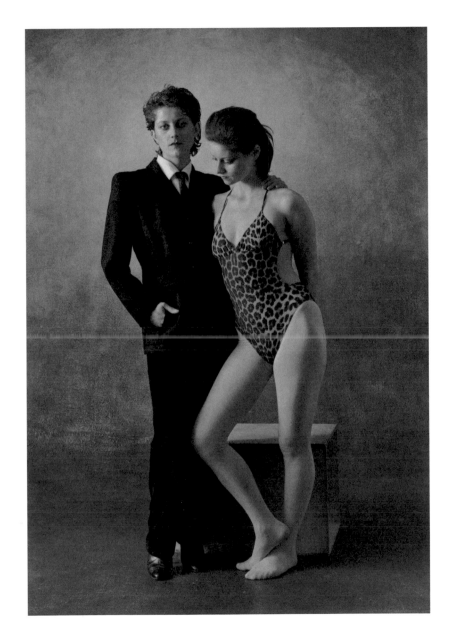

Roberta, Rica

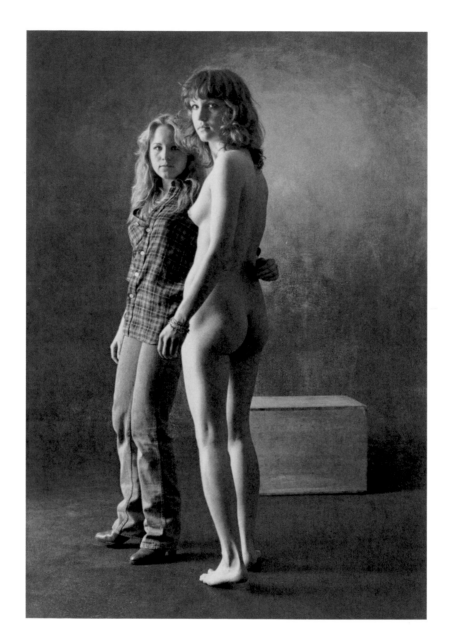

Daniela, Vroni

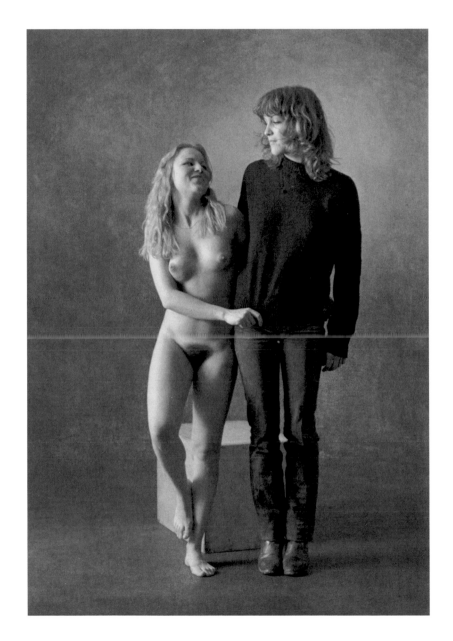

Daniela, Vroni

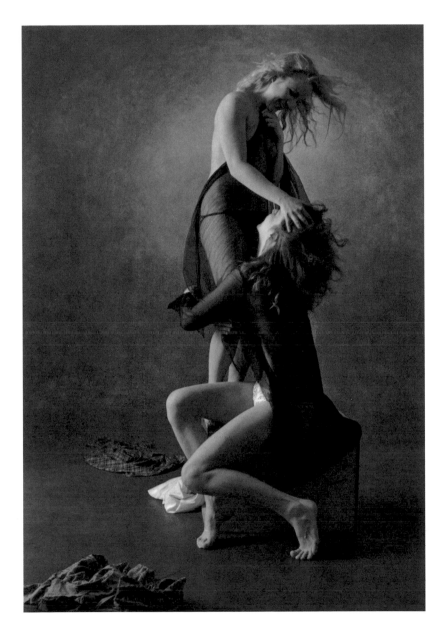

Daniela, Vroni

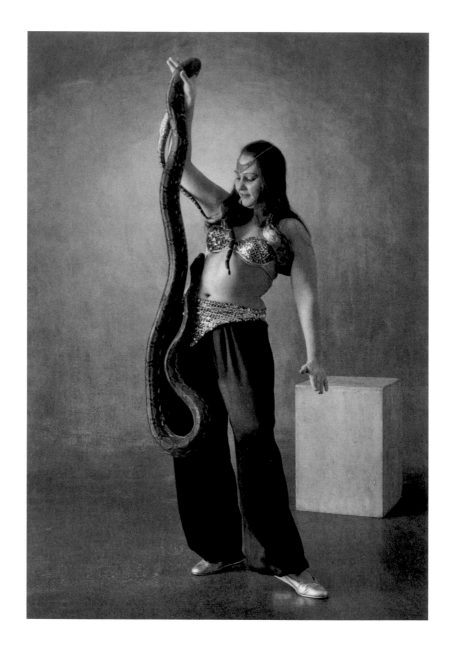

Irma

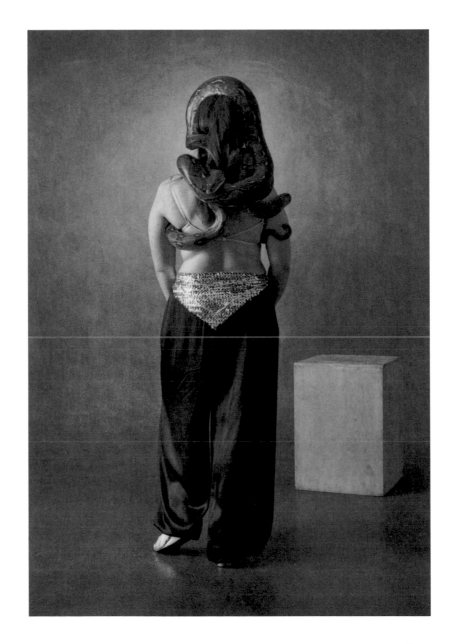

Irma

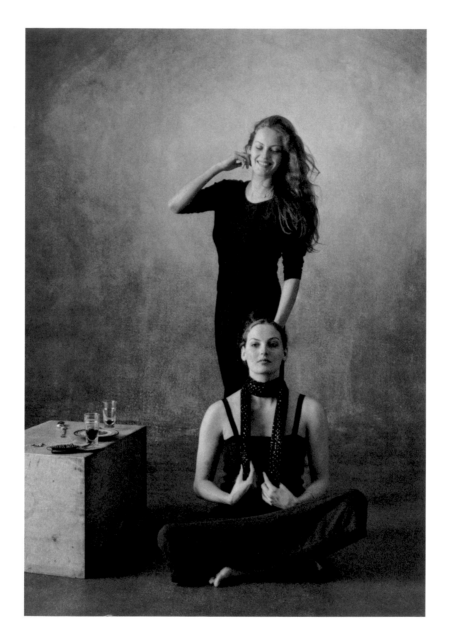

Barbara, Rike

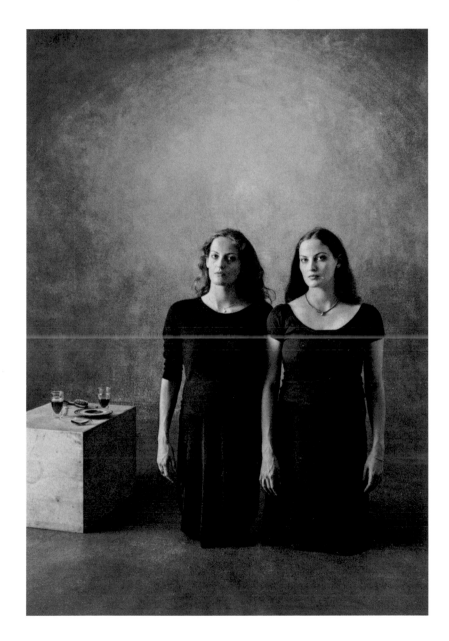

Barbara, Rike

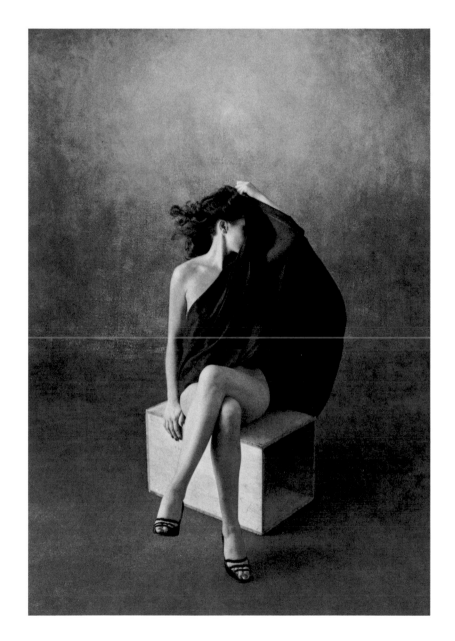

Yvonne

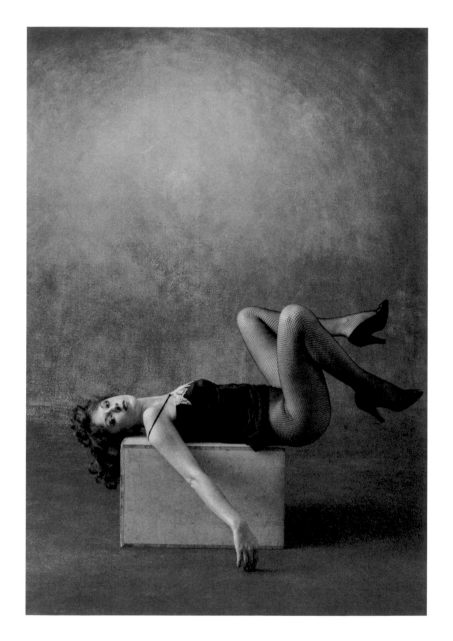

Yvonne

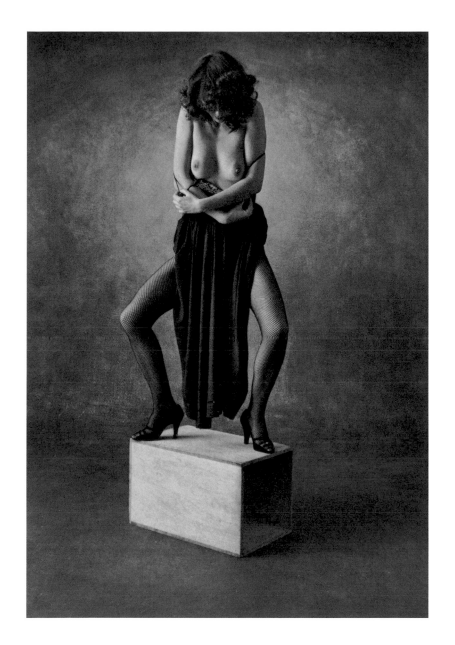

Yvonne

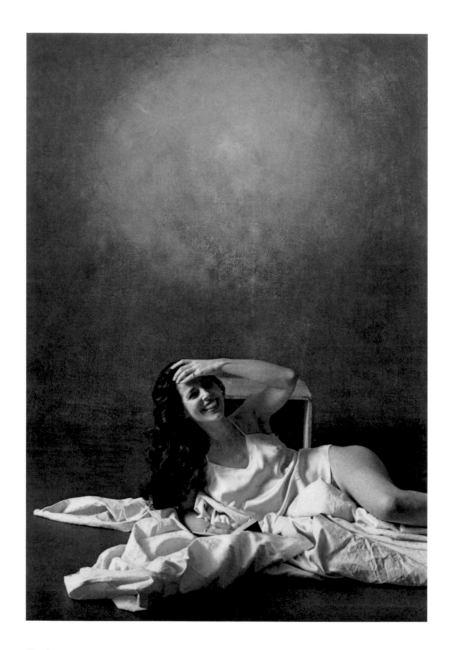

Denise

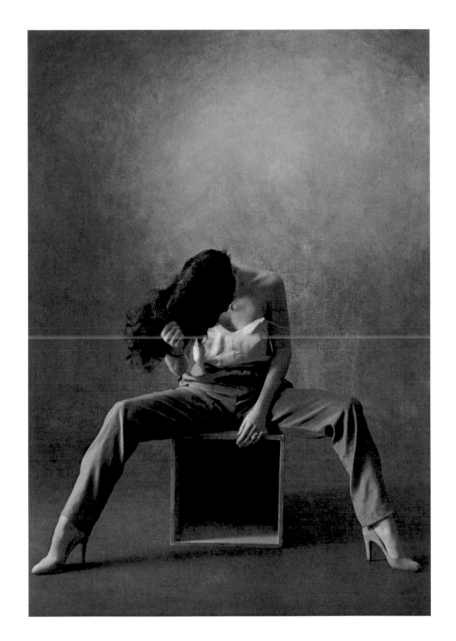

Denise

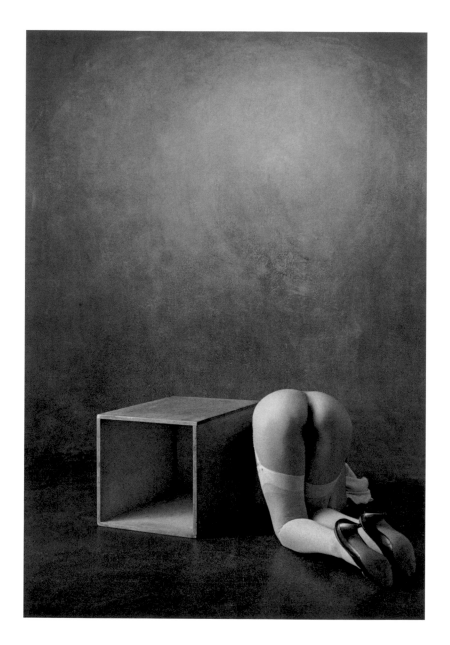

Kim

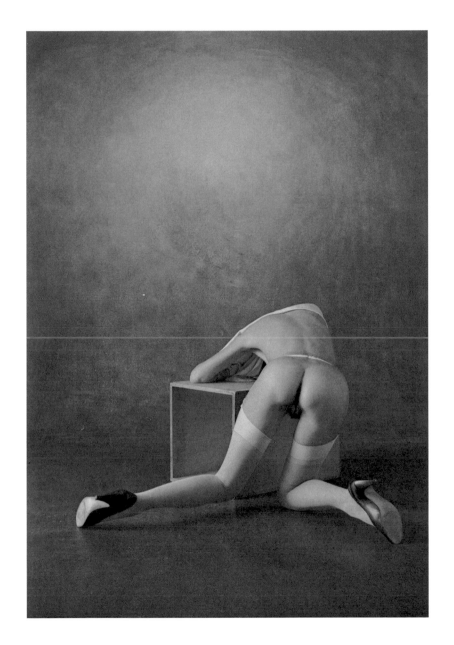

Kim

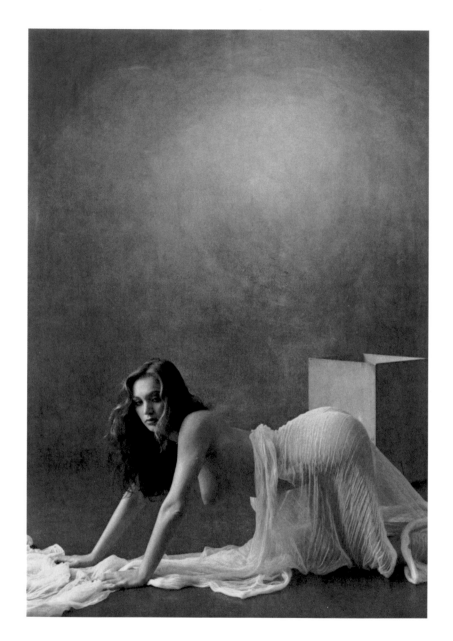

Bianca

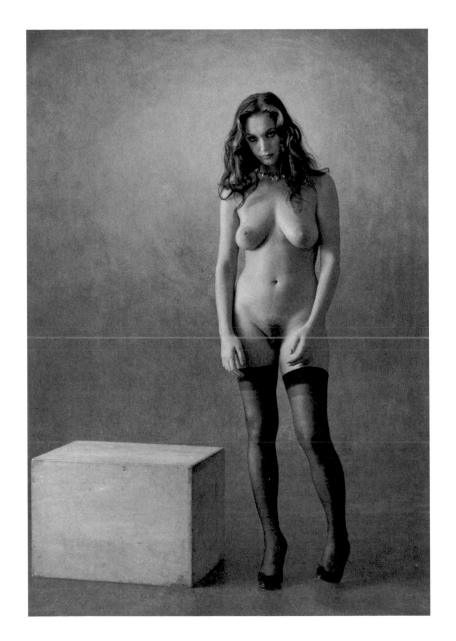

Bianca

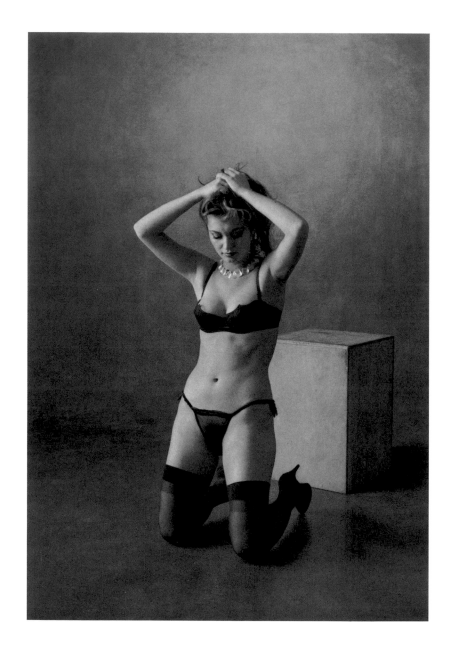

Bianca

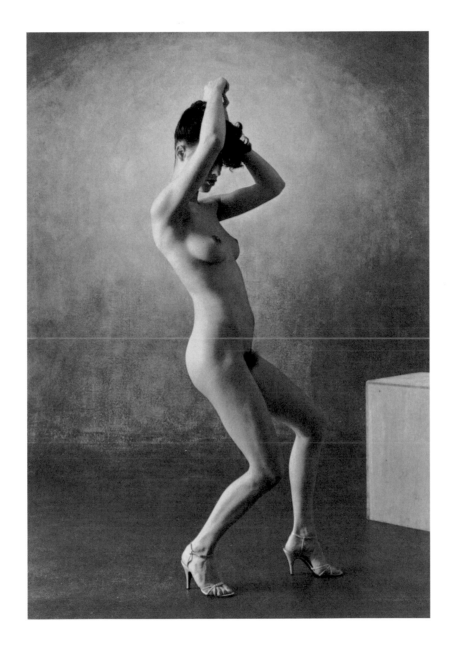

Irène

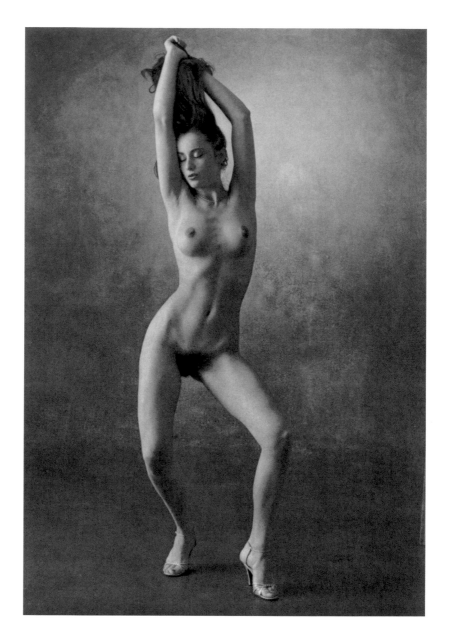

Irène

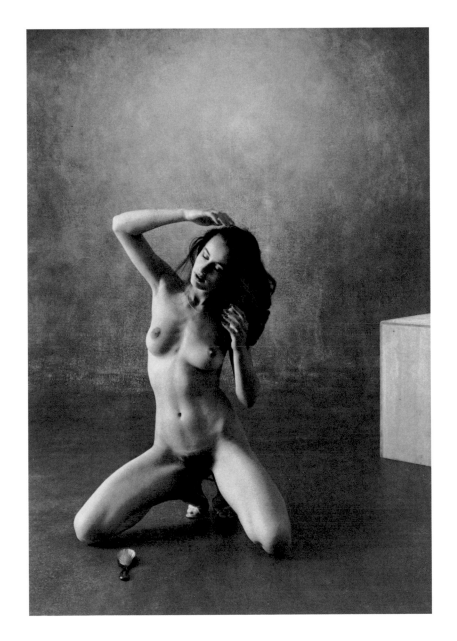

Irène

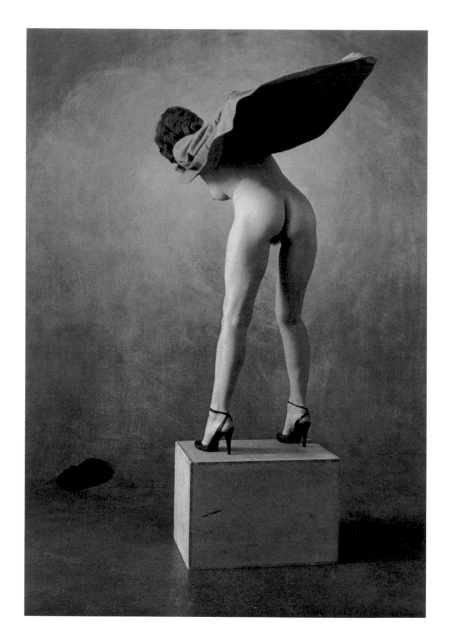

Isabella

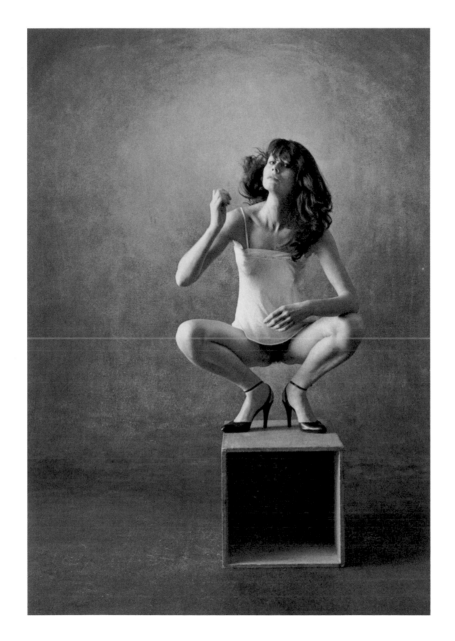

Isabella

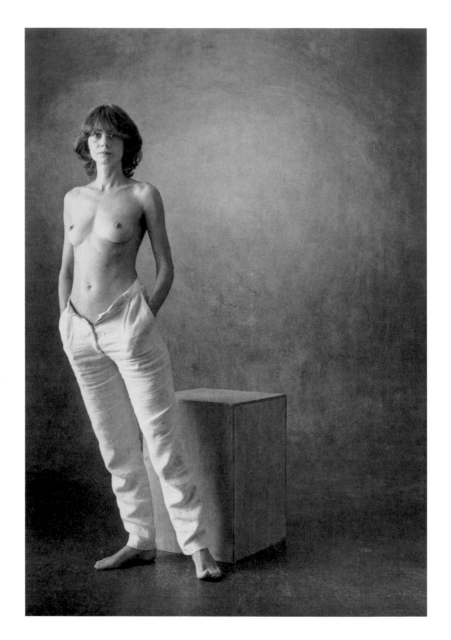

Isabella

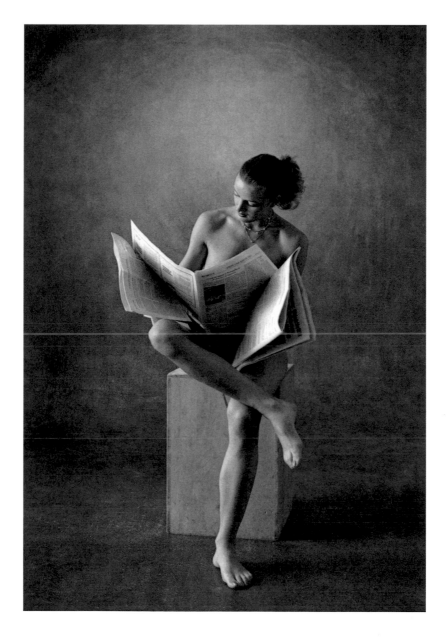

Michaela

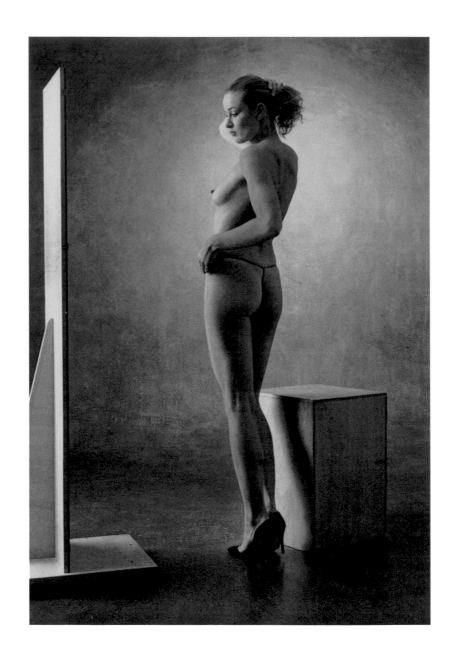

Michaela

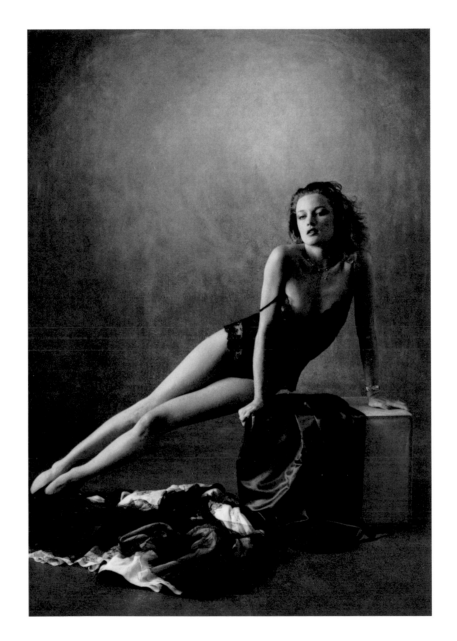

Michaela

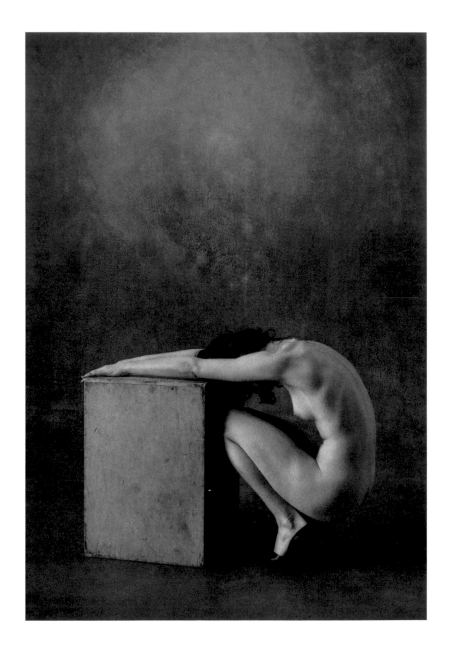

Petra

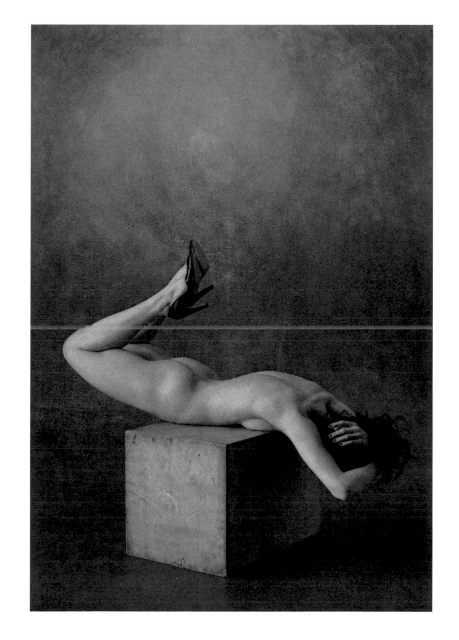

Petra

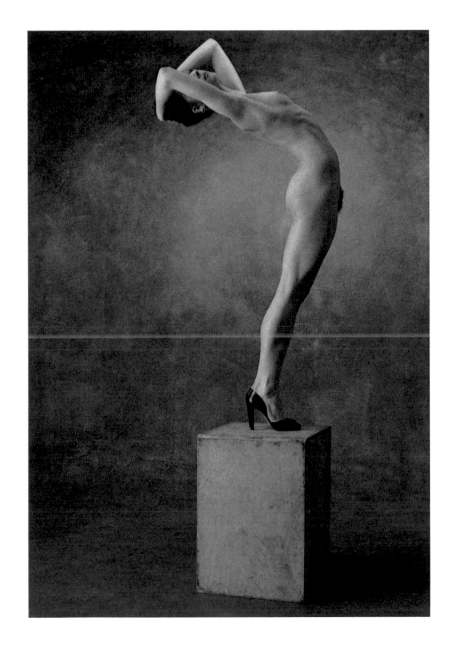

Petra

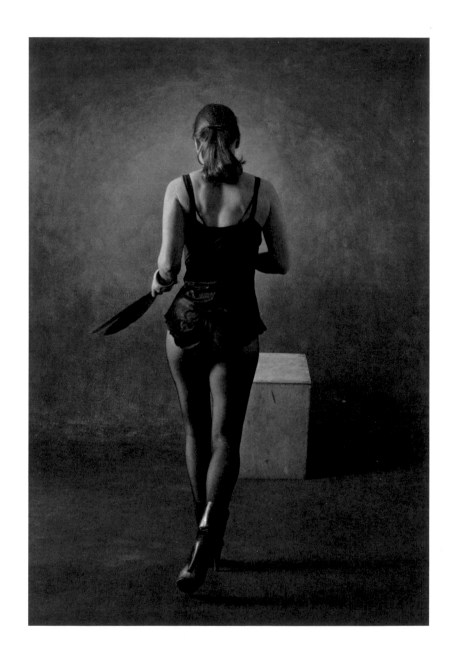

Marianne

I enjoy working with women. I think they are more in tune with their bodies and less abstract about their own sensuality than most men – in our society at least.

I would like to thank all of the women and Isabella and Jean-Pierre Salzmann, for helping make this book possible.

CHRISTIAN VOGT

CHRISTIAN VOGT
Born in Switzerland in 1946; free-lance photographer since 1969. Lives in France and Switzerland.

AWARDS
Swiss Federal Grants
First Grand Prix Triennale de Fribourg
Canada Council Grant
Art Director's Awards Switzerland,
　Germany, New York and Los Angeles
Clio Award, New York
The Art Award of the City of Basle
and other awards

SELECTED
LECTURES AND WORKSHOPS
I.C.P., New York
Swiss Institute, New York
Rencontres Internationales
　de la Photographie, Arles
Venice '79, Venice
University of Coimbra, Porto
Yale University, New Haven
Ryerson Institute, Toronto
St. Lukas Institute, Brussels
Alden Bisen, Belgium
Art Center, College of Design, Vevey
Institute of Design, Milan
Lecture tours in Australia, Denmark,
　Norway and other countries

Consulting expert for Swiss Grants for
Applied Arts / Photography since 1990

SELECTED
GROUP EXHIBITIONS
Photokina, Cologne, Germany
Fotoforum, Kassel, Germany
Museum of Modern Art, Stockholm
Polaroid Exhibition, Centre Pompidou,
　Paris (catalogue)
The Photographer's Gallery, London
Hoffmann Stiftung, Museum für
　Gegenwartskunst, Basle, Switzerland
International Art Fairs in Bologna, Italy
　and Basle, Switzerland
Fotografie in der Schweiz, Swiss
　Foundation for Photography, Zurich,
　Switzerland (book)
Splendeurs et Misères du Corps, Museum
　of Modern Art, Paris (catalogue)
Fotoporto, Casa de Serralves
　(Museum of Modern Art), Porto
Arrangements, Mai 36 Galerie, Lucerne,
　Switzerland
Wichtige Bilder, Museum für Gestaltung,
　Zurich, Switzerland (catalogue)
A la recherche du père, Paris Audiovisuel,
　Paris (catalogue)

SELECTED
SOLO EXHIBITIONS
The Photographer's Gallery, London
ICP, New York
Neikrug, New York
Swiss Institute, New York
Kunsthaus, Zurich, Switzerland
Yajima Gallery, Montreal, Quebec
Galerie Felix Handschin, Basle,
　Switzerland
Focus Gallery, San Francisco
Ray Hawkins Gallery, Los Angeles
The Tel Aviv Museum, Tel Aviv
Rencontres Internationales
　de la Photographie, Arles, France

Galerie Watari, Tokyo
Preuss Museum, Norway
The Edwynn Houk Gallery, Chicago
Galerie CCD, Düsseldorf, Germany
Kunstmuseum, Hanover, Germany
Nostra Descrittiva, Rimini, Italy
Museum für Gestaltung, Basle,
 Switzerland
Musée de l'Elysée, Lausanne, Switzerland
Musco dell'Artc Modcrna, Bologna, Italy
Espace Photographique de la Ville
 de Paris, Paris
Swiss Institute, New York
Architekturmuseum Basel, Basle,
 Switzerland (catalogue)
Galerie Littmann, Basle, Switzerland
Salle Patiño, Geneva, Switzerland

SELECTED PUBLICATIONS
Portfolios and visual concepts for
various magazines, annuals and special
publications including:
Camera International, England
Camera, Switzerland
du, Switzerland
Picture Magazine, U.S.A.
PhotoShow, U.S.A.
Time-Life, International Edition
Light Vision, Australia
Graphis, International Edition
 (represented in diverse annuals)
Vogue, Italy
1983 Ilford Calendar

Visual concepts commissioned by:
Dow Chemical (calendar)
BASF Pharmaceuticals (calendar 1995/96)
Municipality of Arhus (book, co-produc-
 tion with Poul Ib Henricksen)
Livio Vacchini, architect (book)

Hilti (corporate portrait/book)
Hasselblad
Saatchi & Saatchi, London
Polaroid Corporation, Amsterdam,
 Cambridge (MA)
Nestlé (annual reports)

Monographs:
Christian Vogt/Photographs. Geneva:
 RotoVision, 1980.
*In Camera: Eighty-two Images by Fifty-two
 Women.* Geneva: RotoVision, 1982.
Christian Vogt, Photodition 5.
 Schaffhausen: Verlag Photographie, 1983.
Fotografische Notizen und notierte Zufälle.
 Basle: Sphinx Verlag, 1984.
Katzenschattenhase. Basle: Wiese Verlag,
 1988 (english edition: *Catshadowhare,*
 1989, catalogue).
Christian Vogt/Light fingering the piano cover.
 Zurich: Edition Neidhart und Schön, 1,
 1991.

Selected catalogues for exhibition projects:
Innenräume (panoramas),
 Architekturmuseum Basel, Basle, 1990.
Schlachtfelder, Galerie Littmann,
 Basle, 1991.
Bilder einer Ausstellung, Galerie Littmann,
 Basle, 1992.
Idem Diversum, Galerie Littmann,
 Basle, 1995.

Christian Vogt's works are represented in
various public and private collections.

I am not erotic.

Sometimes I am erotic when I'm with someone who likes me and
 whom I like as well.

I cannot make an erotic picture with myself – I don't find myself erotic
 when I take off my clothes.

My breasts are not erotic.

Perhaps they are for someone, when I show them?

As a sign, an invitation…

So I show.

Am I too old?

Can I offer something that is no longer pleasing?

Someone who loves me finds me pleasing.

So … love me.

Text copyright page 5 by Christian Vogt, September 1981
Text copyright by the authors
Editorial direction: Mirjam Ghisleni-Stemmle
Art direction: Susan Nash
Typography: Peter Renn, Teufen, Switzerland
Photolithography: Genoud, Lausanne, Switzerland
Printed and bound: A.G.M. S.p.A., Arese (Milan), Italy

ISBN 3-908162-17-3

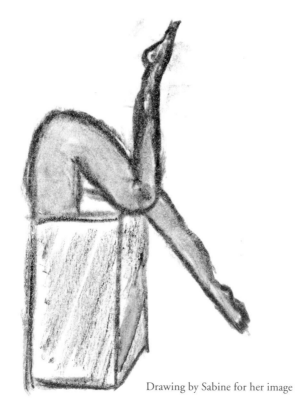

Drawing by Sabine for her image

DATE DUE